Chuck Kelton & Eric William Carroll

New Photogenic Drawings
Curated by Alison Bradley

BOSI Contemporary, New York
March 28 – April 21, 2013

FRONT COVER: CHUCK KELTON, *NIGHT AFTER NIGHT*, (DETAIL)
DESIGN: KARA BROOKS

ISBN: 5-800093-099357

CONTENTS

7 ***Ars Longa, Vita Brevis***
 Alison Bradley

13 **Into The Woods**
 Lyle Rexer

19 **Exhibited Works**

39 **Acknowledgements**

43 **Biographies**

53 **Contributors**

ALISON BRADLEY

"ARS LONGA, VITA BREVIS"

"*Ars longa, vita brevis*", a Latin translation from Greek, is perhaps best interpreted in our time as: "life is short, art is eternal". An artist's life is filled with challenges and, above all, with the self-reconciliation of what they produce. Their work is forged through a deep relationship between ideas and skills, first occurring by chance, then reinforced through repeated practice. For photographers, technique is not defined by a mere click of an apparatus or a rendering of a moment but, instead, by a deeper knowledge of the medium: the history, materials, and foibles.

I met both artists by chance and, as time passed, my initial intuition of their work — being something interesting — became a conviction that their photographs were indeed profound. Chuck Kelton was formerly my own teacher of the art of gelatin silver print. Now, he is the mentor one finds only rarely in a lifetime. I met Eric William Carroll through a discerning collector, in whose home we unfolded (section after section) Blue Line of Woods. We were all enchanted by the book's uniqueness, historicism and strength of vision.

Indeed, I am struck by the fact that both artists share a defiance of the reproducible trait of photography, yet share a reverence for its process and qualities, as well as the alchemical properties and materiality of which it is dependent upon.

In this exhibition, both artists will debut bodies of work and artist books that draw on the legacies of early pioneers in the photographic practice — such as Anna Atkins, Carleton Watkins and Timothy O'Sullivan — and present a compelling new vision.

Carroll and Kelton explore photography in its fullest sense, through processes and subject matter. In their unique works — irreproducible and made without negatives — light and chemistry manifest themselves and create utterly striking renditions of nature.

Carroll's diazotypes are created by his mitigation of light and photosensitive paper in situ in nature, while Kelton's masterful photograms are created in a darkroom, at times devoid of anything botanical or environmental in the process.

In addition to their unique prints, the exhibition will feature books by both artists; Eric William Carroll's "Blue Line of Woods", a limited edition artist book, measuring 11" x 9" x 1.5", composed of accordion bound pigment ink prints with an unfixed gelatin silver print on cover, including a printed text insert, and Chuck Kelton's artist folio, "Night after Night", comprising nine unique, hand toned, photograms.

Please enjoy this exhibition of unique works and artist books.

Lyle Rexer

INTO THE WOODS

Everywhere we look, nature confronts us – in images at least. Yet in bringing us other places, photography seems to have unanchored us from place, made nature a spectacle without a message, and catalogued the sublime as a first step in its domestication and ultimate exploitation. In a famous series by Myoung Ho Lee, trees are photographed against canvas backdrops, like props from a nineteenth century photo studio. Nature has become a mere sign, with no power of authorship.

Yet the earliest photographers felt differently. In *The Pencil of Nature*, William Henry Fox Talbot celebrated nature's ability to draw itself, through the medium of light and paper. His contemporary Oliver Wendell Holmes suggested that reality gives off a film from its surfaces, which somehow impresses itself on the photographic negative. At the beginning, then, photography was not merely a matter of images or "signs," but of impressions, contact.

Just at a time when images seem to have lost their power to inspire a reverence for nature (the pictures just get bigger and bigger), the works of Eric William Carroll and Chuck Kelton take on a subtle urgency. They restore to photography a sense of physical touch that confirms the world. Both these artists are deeply immersed in the process of making cameraless, chemical photographs, and both have sought a means to represent nature by recording its physical condition. They have convened physical events and harnessed chance to make pictures. Carroll's diazotypes (more familiarly known as blueprints, a technique as old as the 1840s) are rich in visual texture and metaphor. Carried into the woods and laid on the sun-dappled ground, the paper registers the shadows cast by the moving branches. Developing yields the evocative blue color of "Blue Line of Woods." The process seems to have captured Holmes' "film" of the real.

To make the point in a slightly different way, Carroll set up a movie screen in the woods and let light and shadow compose the shifting images on screen – nature's home movie. Of course we are at a remove from the source: we could just watch the light through the trees without recourse to the screen. Yet the screen suggests a collaboration between nature and the artist in the production of images and reminds us that our intrinsic aesthetic sense is the means by which we identify where we are. Walking cameras, we register conditions and frame the landscape.

More tactile are Chuck Kelton's photograms, which involve the direct placement of objects on paper to create a silhouette image when exposed to light. Once again, no cameras are involved, and the control of exposure yields the delicate gradations of opacity and transparency. The paper records a physical contact with objects and light, just as it would have 150 years ago. Kelton has produced moonlight exposures of trees and foliage, pale night versions of Carroll's natural world. Nature performs under the orchestration of the artist.

Yet Kelton has also fabricated illusory "landscape" photograms in the darkroom, from the contours of rocks, cans, wood and other materials placed on the paper. He has augmented the initial image with chemical toning of the print to produce rich and strange background hues. The result is a hybrid: part illusion, part document; part painting, part photograph; part image, part object.

In a media-saturated world where nature is known through images, Kelton and Carroll dispense with the camera to demonstrate the embodied reality of nature. Nature is not a picture, it makes pictures. We live within it, and it touches us.

EXHIBITED WORKS

CHUCK KELTON

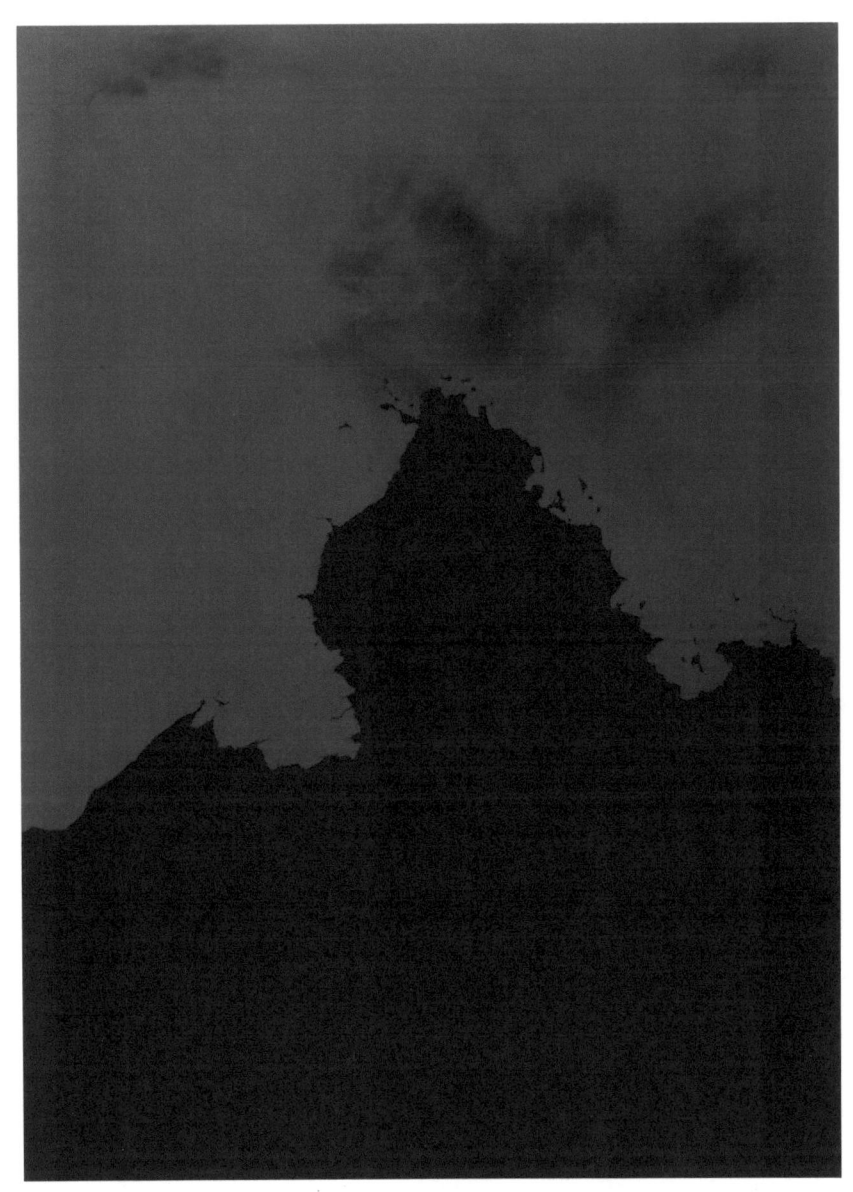

Night After Night 2012 19.25 x 23 in
Unique Hand Toned Gelatin Silver Prints

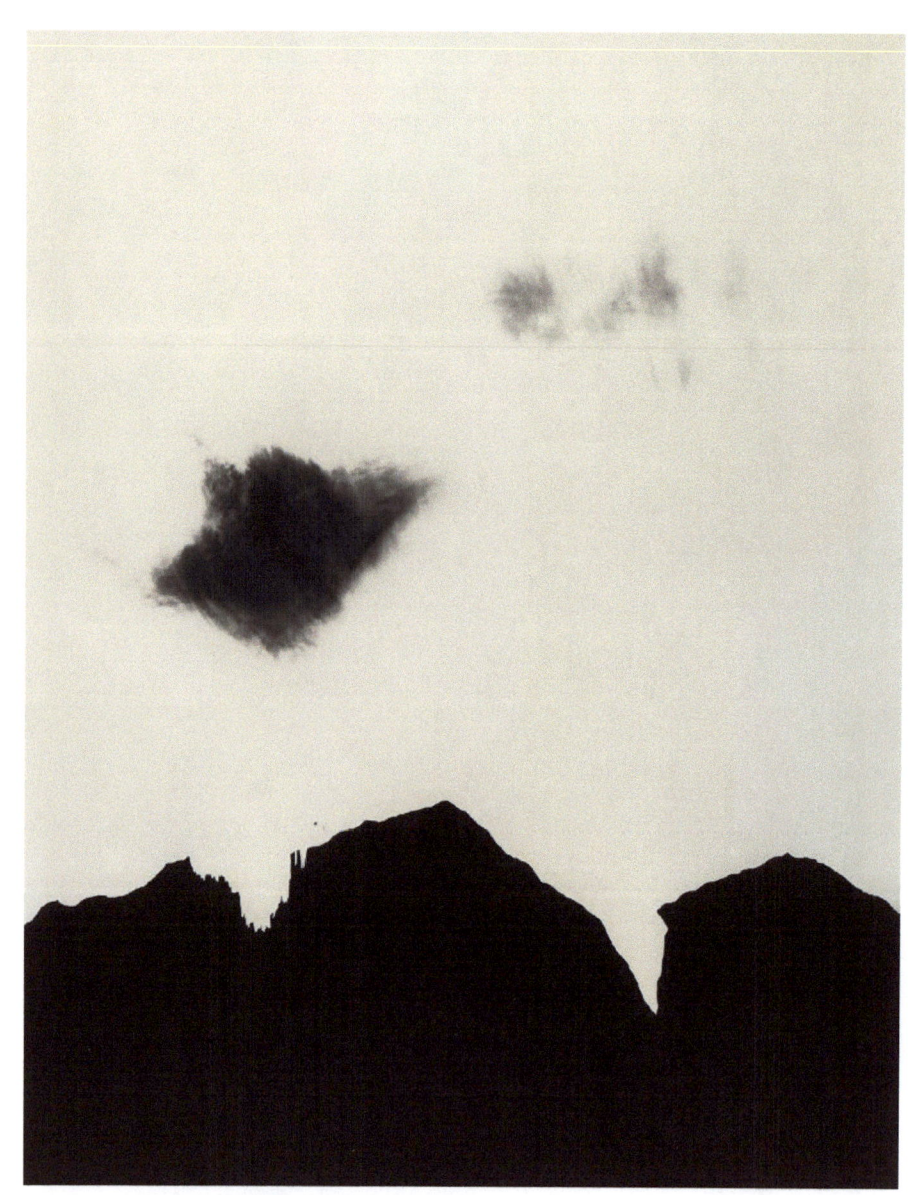

NIGHT AFTER NIGHT 2012 19.25 x 23 IN
UNIQUE HAND TONED GELATIN SILVER PRINTS

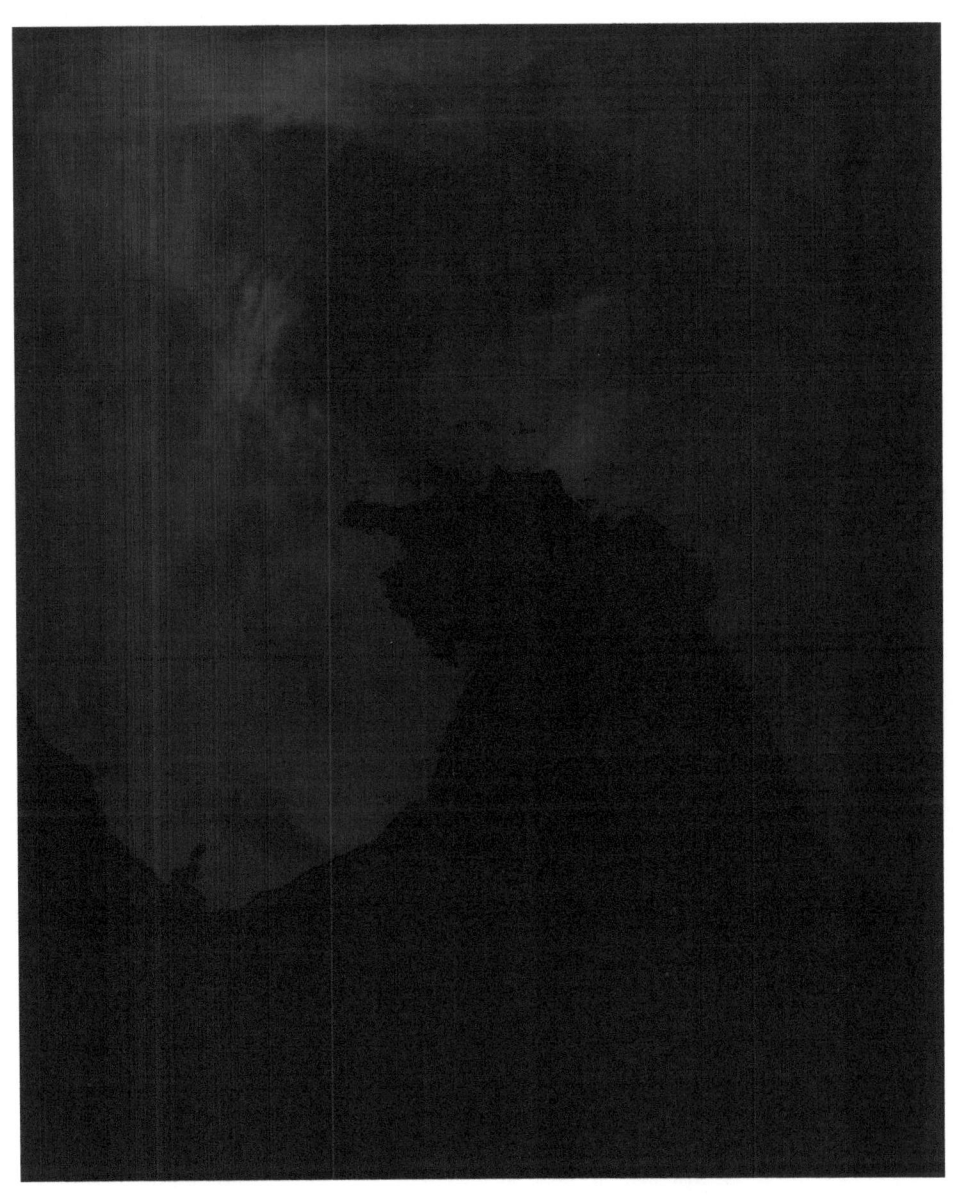

Night After Night 2012 19.25 × 23 in
Unique Hand Toned Gelatin Silver Prints

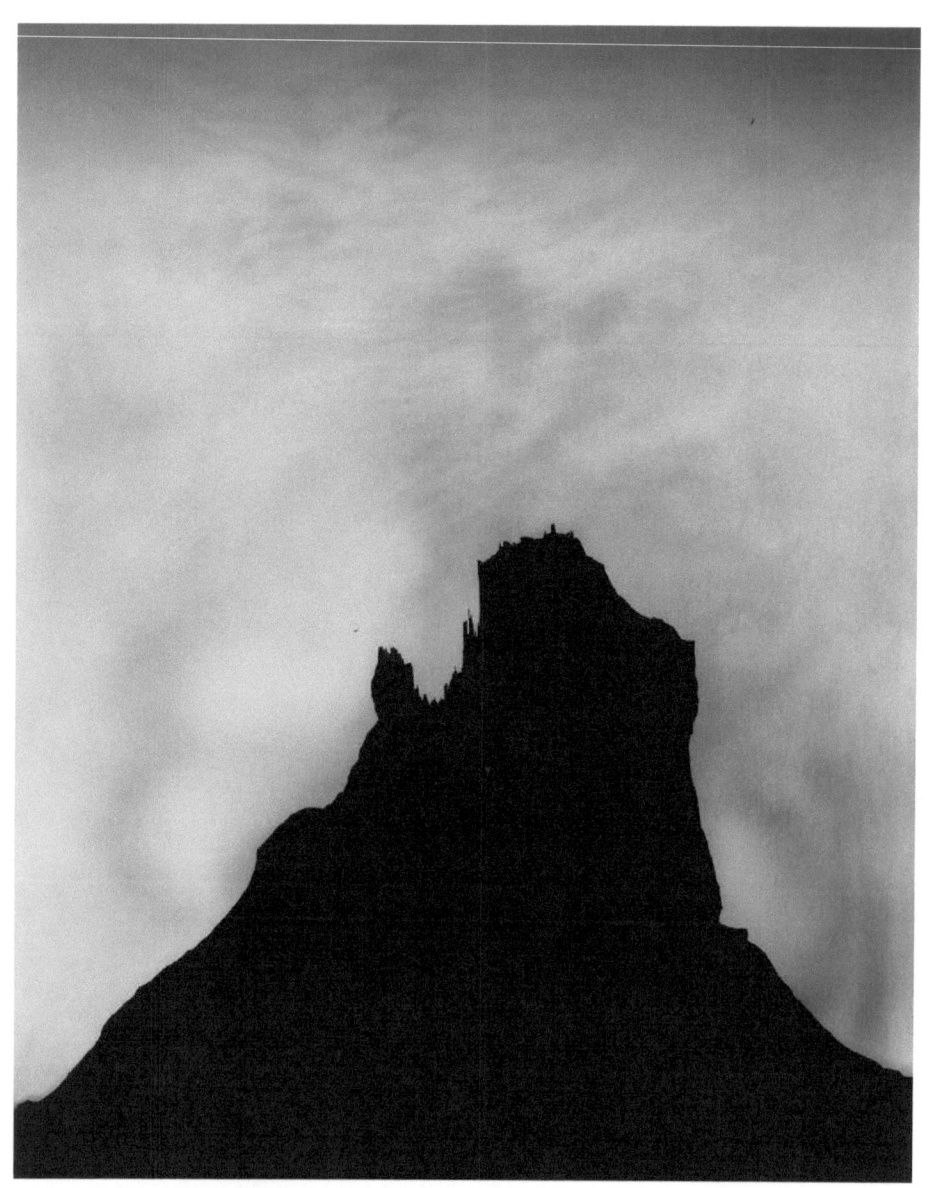

Night After Night 2012 19.25 x 23 in
Unique Hand Toned Gelatin Silver Prints

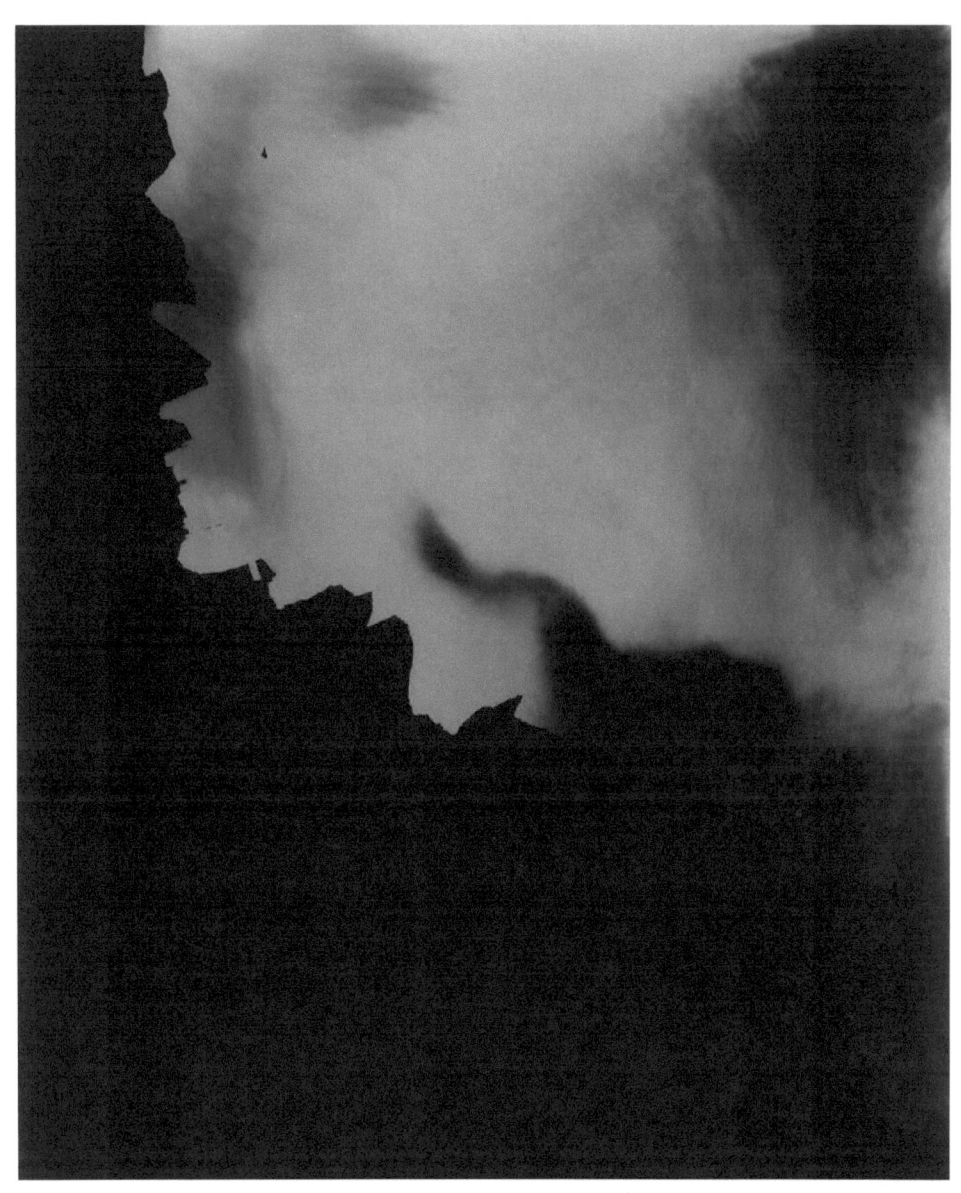

Night After Night 2012 19.25 x 23 in
Unique Hand Toned Gelatin Silver Prints

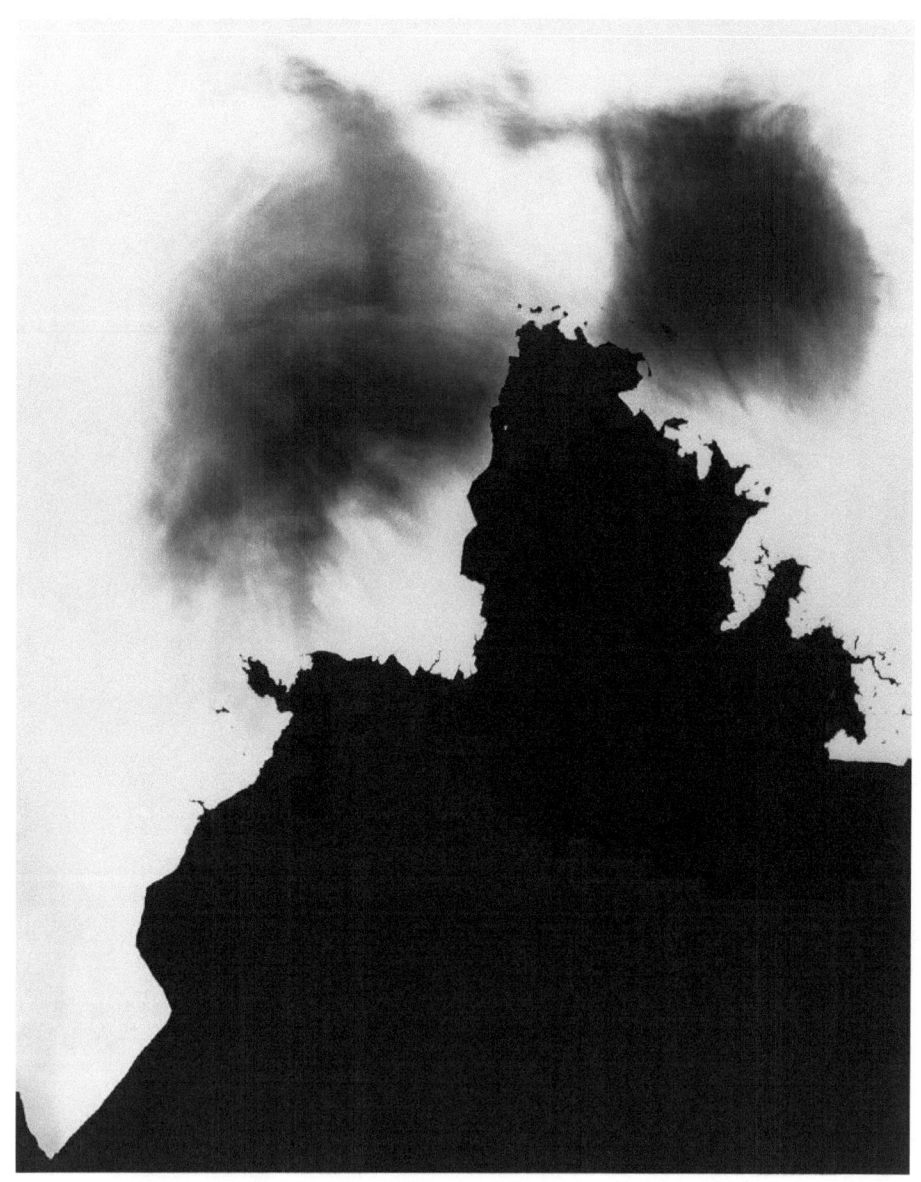

NIGHT AFTER NIGHT 2012 19.25 x 23 IN
UNIQUE HAND TONED GELATIN SILVER PRINTS

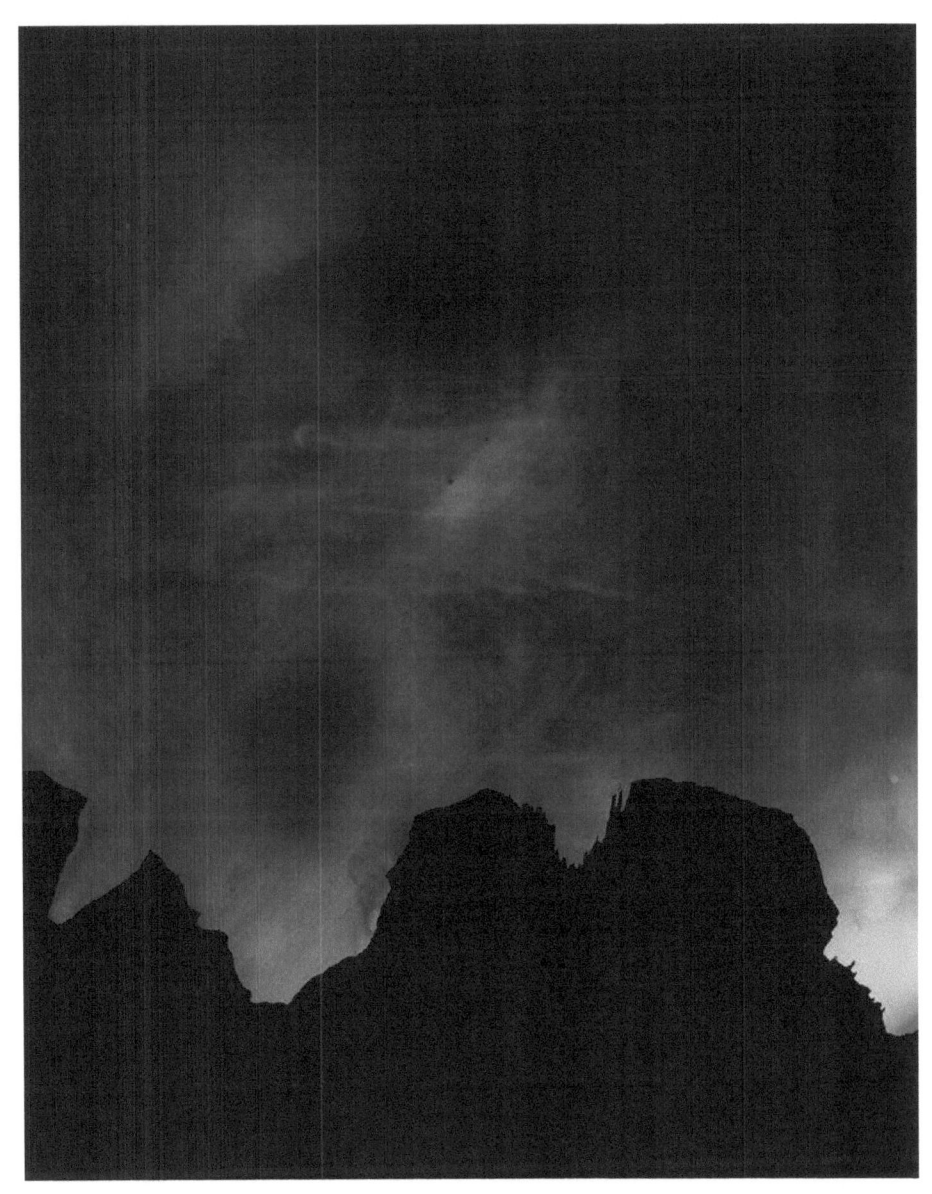

Night After Night 2012 19.25 x 23 in
Unique Hand Toned Gelatin Silver Prints

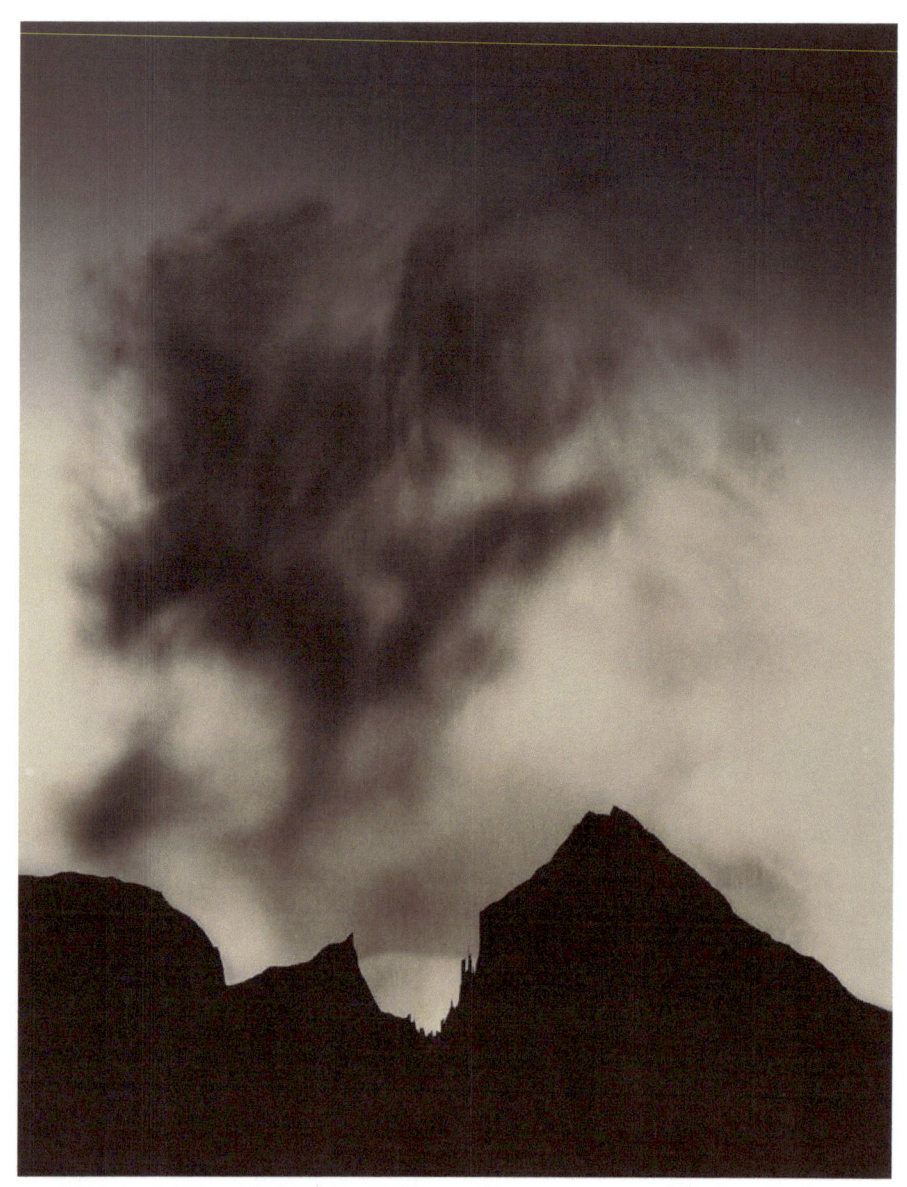

Night After Night 2012 19.25 x 23 in
Unique Hand Toned Gelatin Silver Prints

NIGHT AFTER NIGHT 2012 19.25 x 23 IN
UNIQUE HAND TONED GELATIN SILVER PRINTS

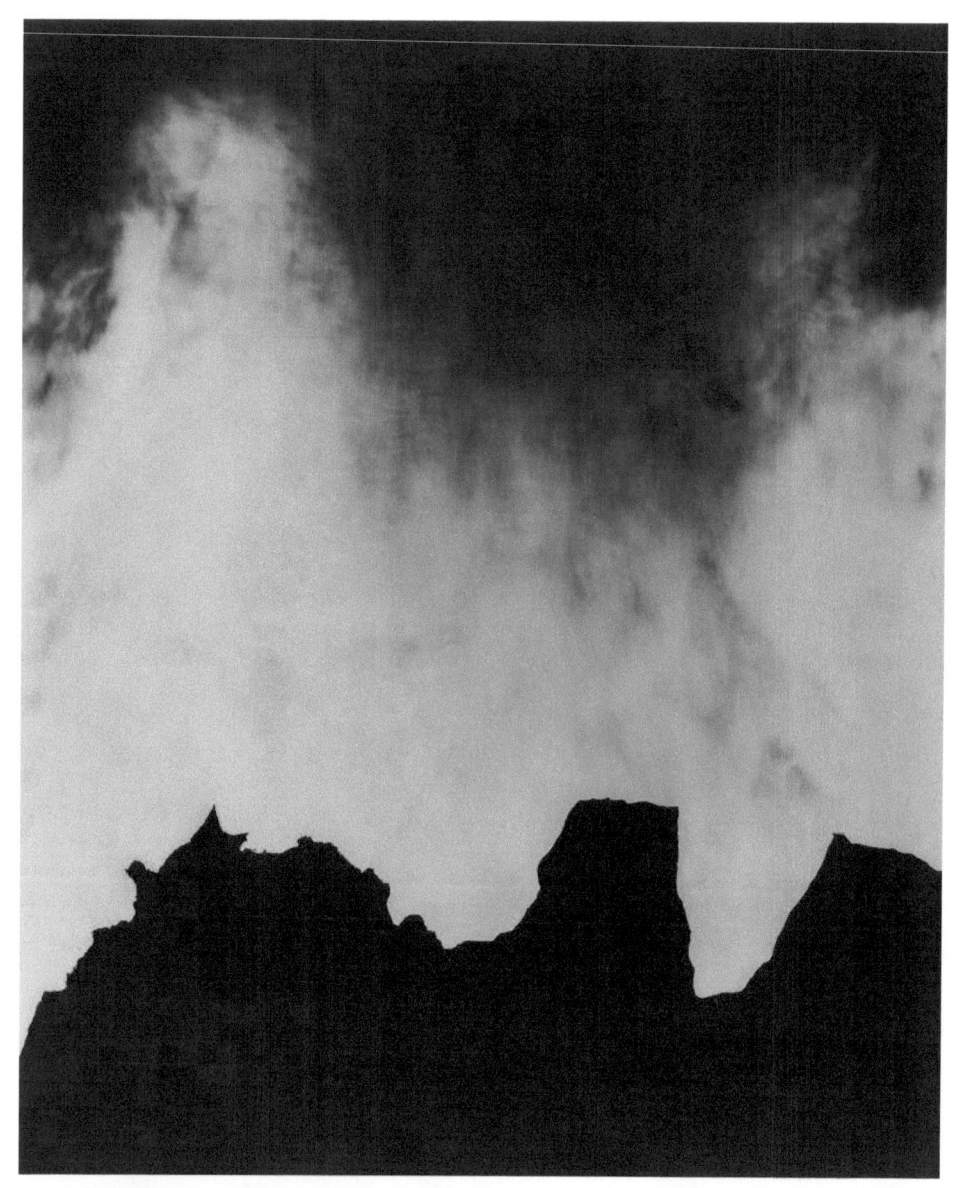

Night After Night 2012 19.25 x 23 in
Unique Hand Toned Gelatin Silver Prints

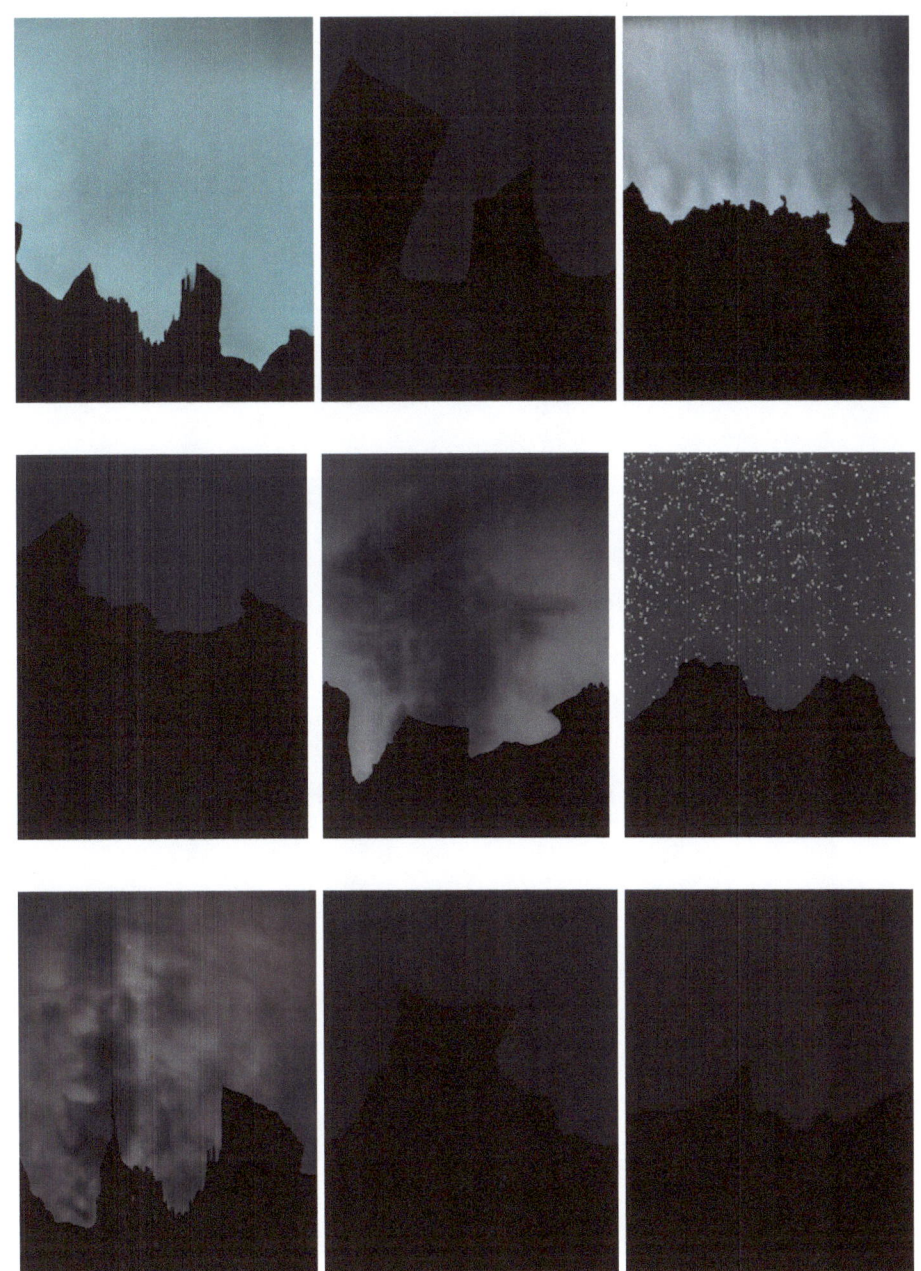

Folio of 9 prints *Night After Night* 7.5 x 9.5 in (each print)
Unique Hand Toned Gelatin Silver Prints

ERIC WILLIAM CARROLL

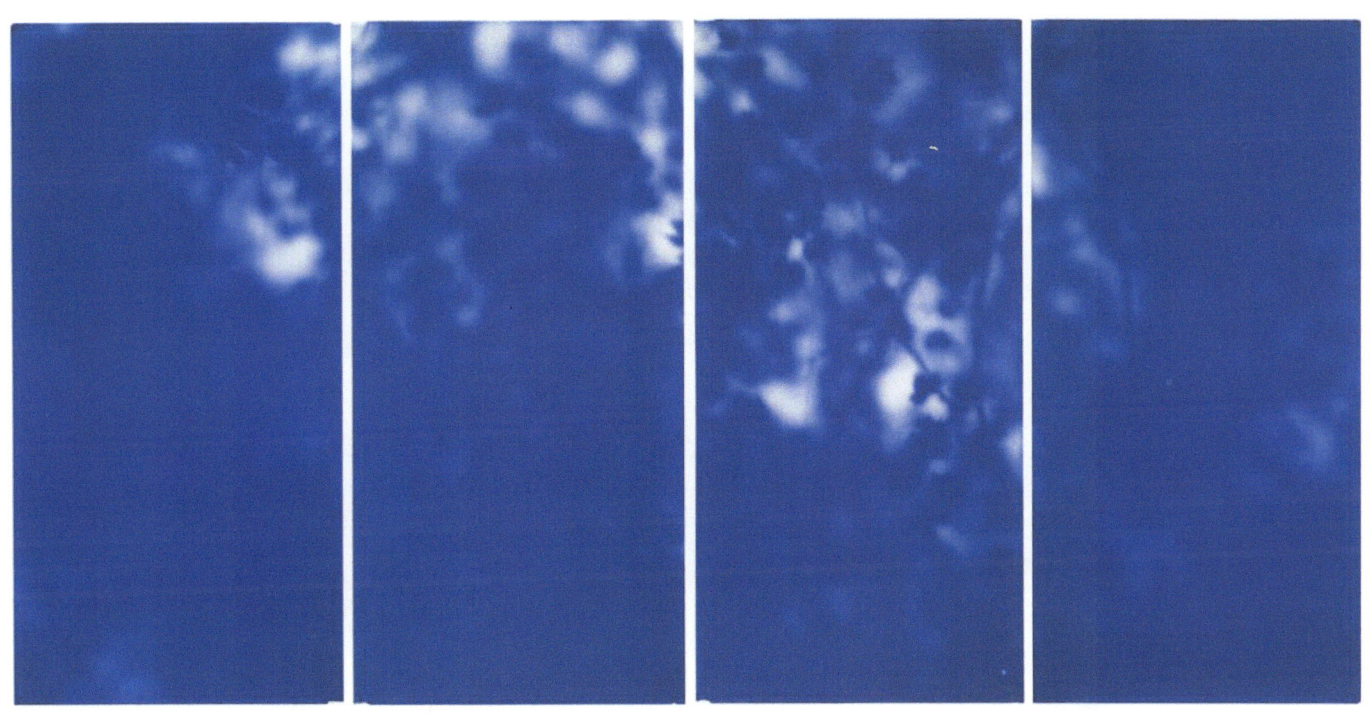

BLUE LINE OF WOODS #911-914 2010 DIAZOTYPE 72 x 36 IN. (EACH PANEL)

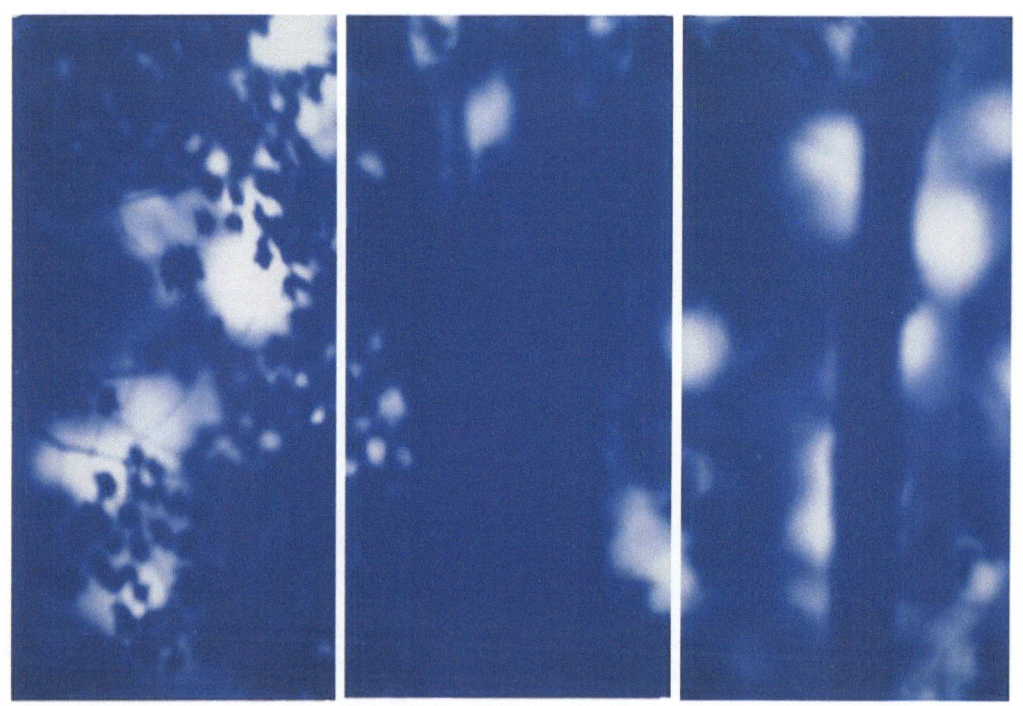

Blue Line Of Woods #1103-1105 2010 Diazotype 72 x 36 in. (each panel)

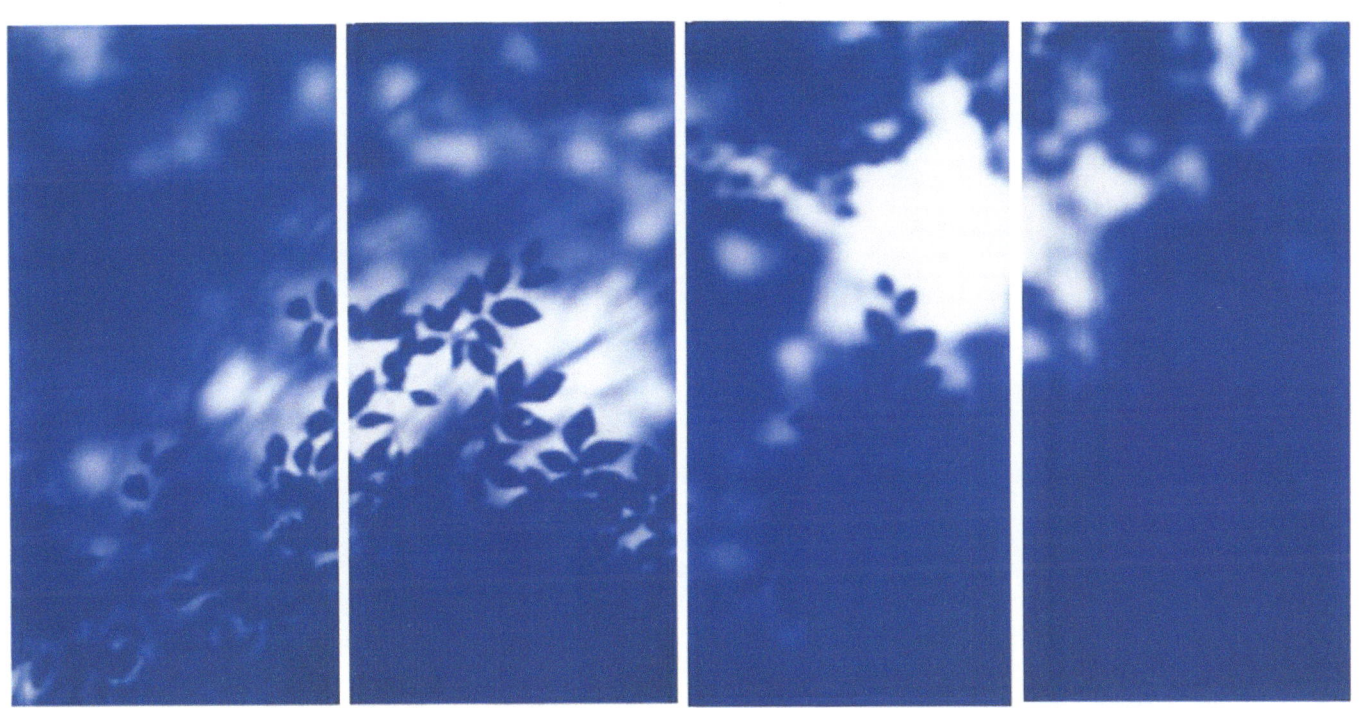

Blue Line Of Woods #1122-1125 2010 Diazotype 72 x 36 in. (each panel)

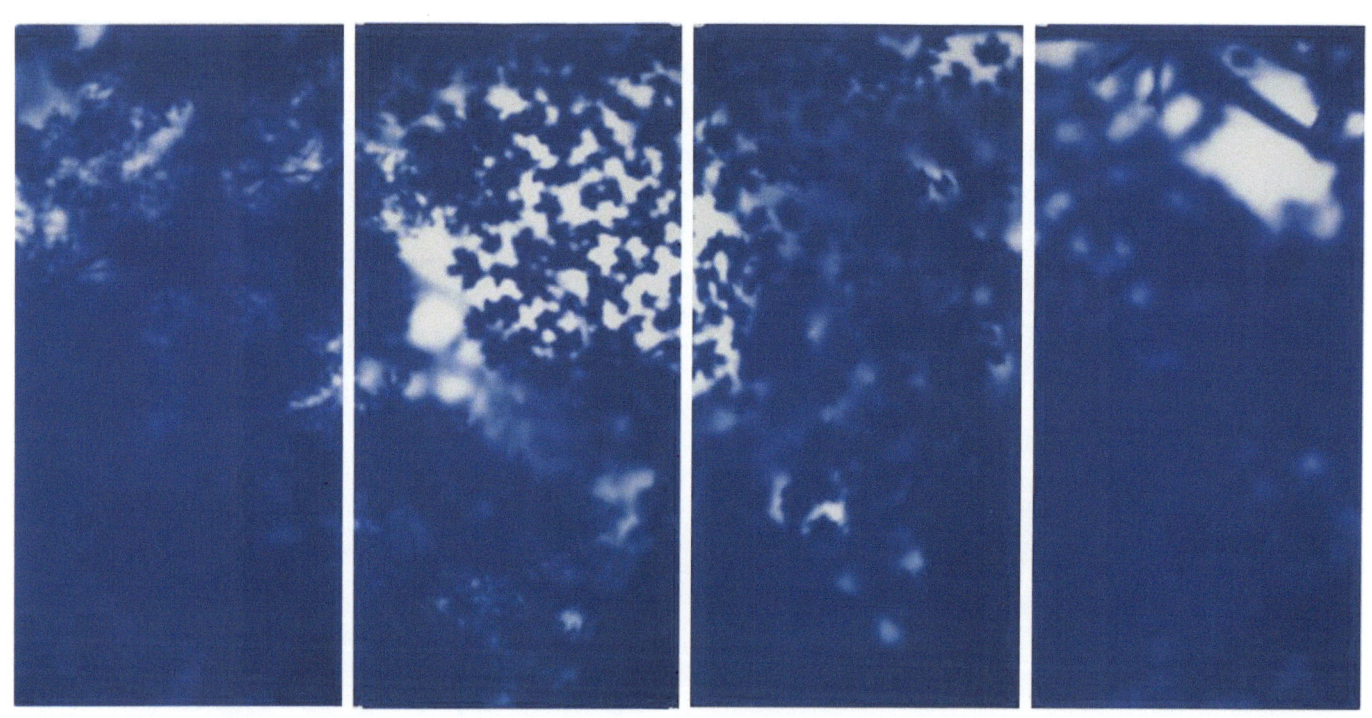

Blue Line Of Woods #1130-1133 2010 Diazotype 72 x 36 in. (each panel)

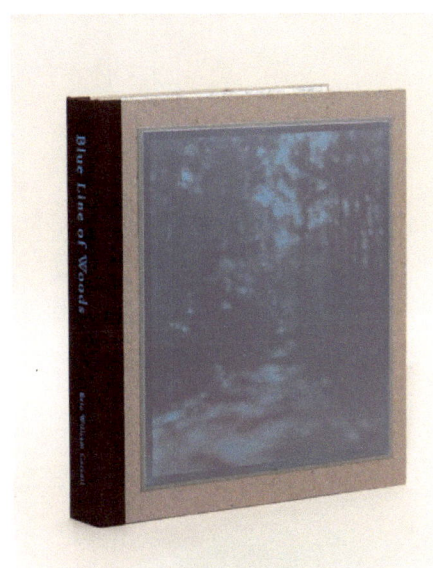
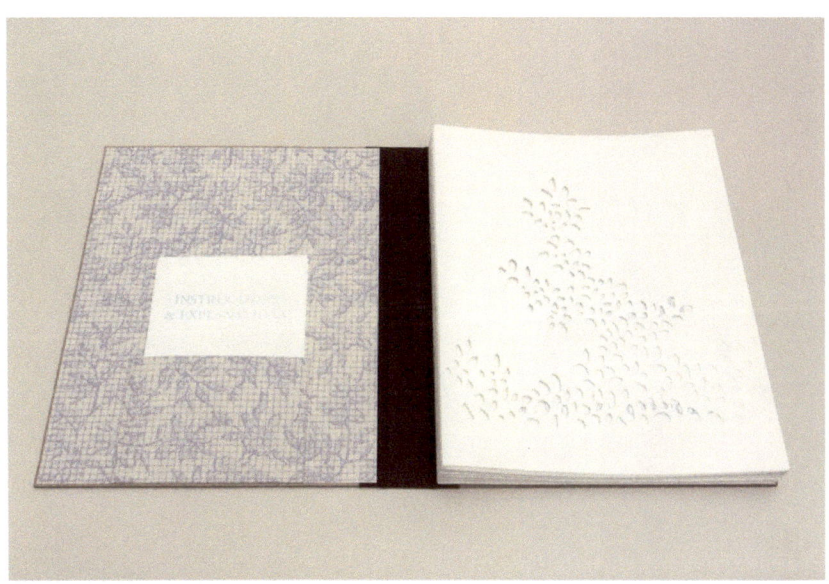
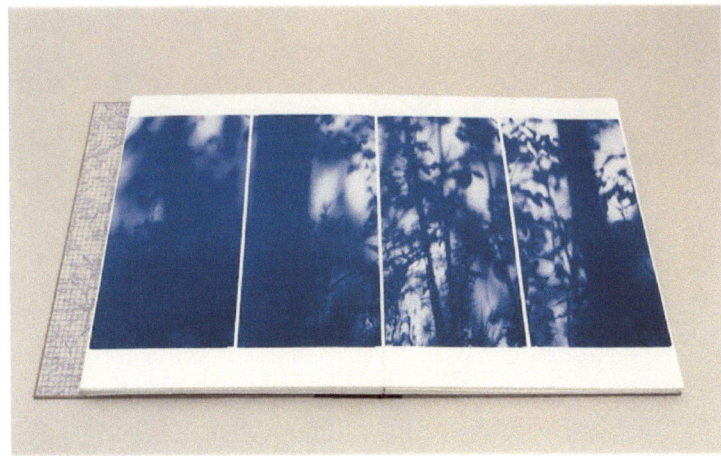
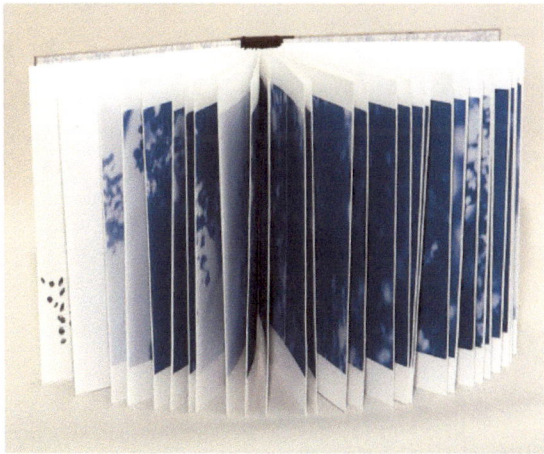

Blue Line Of Woods Artist Book 2012

37

ACKNOWLEDGEMENTS

I would like to give a very special thank you to Sandro Bosi for believing in this show and to Kara Brooks and the staff at Bosi Contemporary. I would also like to exend a special thanks to Alma Bradley, Lulu Bradley, Fabio Cutro, Peter Flessig, Lizzie Himmel and Leslie Sheryll, without whose support this exhibition would have not been possible.

Alison Bradley

BIOGRAPHIES

CHUCK KELTON

CHUCK KELTON IS A WELL-KNOWN FIGURE IN THE PHOTOGRAPHY WORLD. AS ONE OF THE FOREMOST PRINTERS OF BLACK AND WHITE PHOTOGRAPHY IN THE UNITED STATES, HE IS DISTINGUISHED BOTH FOR HIS ABILITIES IN THE DARKROOM, AS WELL AS HIS LONG-TERM RELATIONSHIPS AND COLLABORATIONS WITH THE ARTISTS THAT HE PRINTS. KELTON IS ALSO AN EDUCATOR. HE CURRENTLY TEACHES AT ICP AND PRIVATELY FOR MASTER SEMINARS.

EDUCATION

1977 OHIO UNIVERSITY, ATHENS, OH. MFA PHOTOGRAPHY / ART HISTORY
1975 KANSAS CITY ART INSTITUTE KANSAS CITY, MO. BFA PHOTOGRAPHY

SELECTED EXHIBITIONS

2012 MANA CONTEMPORARY, JERSEY CITY, NJ.
 ROBERT ANDERSON GALLERY, GROUP SHOW, NEW YORK, NY.
 CAUSEY GALLERY OF CONTEMPORARY ART, BROOKLYN, NY.
2011 ROBERT ANDERSON GALLERY, WORKS ON PAPER, NEW YORK, NY.
2010 THE MONMOUTH MUSEUM, GROUP SHOW, LINCROFT, NJ.
 CAUSEY GALLERY OF CONTEMPORARY ART, BROOKLYN, NY.
2009 INTERNATIONAL CENTER OF PHOTOGRAPHY EDUCATION GALLERY,
 GROUP SHOW, NEW YORK, NY.
 INGENIOUS METHODOLOGY, GROUP SHOW, CAUSEY GALLERY OF CONTEMPORARY
 ART, BROOKLYN, NY.
2007 *LINE DRAWING*, GROUP SHOW, QUEENS LIBRARY GALLERY, QUEENS, NY.
 PIP PHOTOGRAPHY FESTIVAL, PHOTOGRAPHY FAIR & GROUP SHOW, CHINA.
 CH'I CONTEMPORARY ART, GROUP SHOW, BROOKLYN, NY.
 HOXIE GALLERY, GROUP SHOW, WESTERLY, RI.
 CROSSROADS GALLERY, GROUP SHOW, KANSAS CITY, MO.
1987 HEDGEPETH GALLERY, NEW YORK, NY.
1986 HEDGEPETH GALLERY, NEW YORK, NY.
1982 FOCAL, PUBLICATION, BRUXELLES, BIBLIOTHEQUE NATIONAL, MUSEUM
 COLLECTION, PARIS, FRANCE.

PROFESSIONAL EXPERIENCE

SINCE 1986:
OWNER: KELTON LABS, NEW YORK, NY.
ONE OF THE FOREMOST LBAS SPECIALIZED IN EXHIBITION & PORTFOLIO GELATIN SILVER PRINTS IN THE UNITED STATES. FOUNDED BY CHUCK KELTON.
OVER THREE DECADES WORKING WITH ARTISTS SUCH AS LILLIAN BASSMAN, LOUIS FAURER, LARRY FINK, DANNY LYONS, HELEN LEVITT, VERA LUTTER, MARY ELLEN MARK, CLIFFORD ROSS, AND LOUIS STETTNER.

PRIOR EXPERIENCE INCLUDED:
BLACK AND WHITE PHOTOGRAPHY PRINTING AND PROCESSING
1981 – 1986 FREELANCE PHOTOGRAPHER AND PRINTER
1979 – 1981 220 PRINT, NEW YORK, NY. CO-OWNER
WORKED DIRECTLY WITH LISETTE MODEL

FACULTY/TEACHING POSITIONS/WORKSHOPS

SINCE 1990:
ADJUNCT PROFESSOR, ICP PHOTOGRAPHY DEPARTMENT, NEW YORK, NY.
COURSE INCLUDES:
SPECIALIZED PROGRAM OF YEARLONG ONGOING STUDIES IN PHOTOGRAPHIC PROCESSES AND ART MAKING.
ADJUNCT PROFESSOR IN BOTH THE (FORMER) ICP/NYU MFA PHOTOGRAPHY PROGRAM AND THE CURRENT ICP/BARD MFA PHOTOGRAPHY PROGRAM.

ONGOING & PAST WORKSHOPS:
PROJECT BASHO, PHILADELPHIA, PA.
UNIVERSITY OF WYOMING, LARAMIE, WY.
WOODSTOCK CENTER FOR PHOTOGRAPHY, WOODSTOCK, NY.
ANDERSON RANCH ARTS CENTER, SNOWMASS VILLAGE, CO.
PETERS VALLEY ARTS CENTER, LAYTON, NJ.
PHOTOGRAPHY WORKSHOP FOR NATIVE AMERICAN TEENS (WITH DANNY LYON), NM

ERIC WILLIAM CARROLL

Eric William Carroll is a San Francisco based artist. His work has been exhibited internationally, as well as at venues including the New Orleans Museum of Art, the Camera Club of New York, the Museum of Contemporary Photography and SF Camerawork. Carroll has participated in residencies with the MacDowell Colony, Rayko Photo Center and the Blacklock Nature Sanctuary, and in 2012 was the winner of the Baum Award for Emerging Photographers.

EDUCATION

2006 UNIVERSITY OF MINNESOTA, TWIN CITIES. MFA PHOTOGRAPHY
2002 COE COLLEGE, CEDAR RAPIDS, IOWA BA PHILOSOPHY

SOLO & TWO-PERSON EXHIBITIONS

2013 *G.U.T. FEELING*, GIGHLIGHT GALLERY, SAN FRANCISCO, CA.
 NEW PHOTOGENIC DEAWINGS, BOSI CONTEMPORARY, NEW YORK, NY.
2012 *BAUM AWARD: ERIC WILLIAM CARROLL*, SF CAMERAWORK, SAN FRANCISCO, CA.
2011 *PLATO'S HOME MOVIES*, RAYKO PHOTO CENTER, SAN FRANCISCO, CA.
2010 *THE SPEED OF DARK*, MICHAEL MAZZEO GALLERY, NEW YORK, NY
2008 *ALL BUILDINGS DREAM IN BLUEPRINTS*, CHRISTENSEN CENTER GALLERY, MINNEAPOLIS, MN.
 SUNBURN, ROCHESTER ART CENTER, ROCHESTER, MN.
2007 *SUNBURN*, MINNESOTA CENTER FOR PHOTOGRAPHY, MINNEAPOLIS, MN.
 HUMAN ERROR, SINCLAIR GALLERY, CEDAR RAPIDS, MN.
 DECOUPLER, UMBER GALLERY, MINNEAPOLIS, MN.
2006 *WHILE SLEEPING*, NORMANDALE COMMUNITY COLLEGE, BLOOMINGTON, MN.
 CAMERA OBSCURA, KATHERINE NASH GALLERY, MINNEAPOLIS, MN.
2005 *MY SENTIMENTS, EXACTLY*, REGIS CENTER FOR ART, MINNEAPOLIS, MN.
 A NIGHT OF NEW MUSIC AND NEW MEDIA, CSPS, CEDAR RAPIDS, IA.
2004 *SIXTEEN CANDLES*, UNIVERSITY OF WISCONSIN, WASSAU, WI.

GROUP EXHIBITIONS

2013 *TAKE ME AWAY*, SFAC GALLERY, SAN FRANCISCO, CA.
 STAKING CLAIM A CALIFORNIA INVITATIONAL, MUSEUM OF PHOTOGRAPHIC ARTS, SAN DIEGO, CA.
 LANDSCAPE, PIER 24 PHOTOGRAPHY, SAN FRANCISCO, CA.
2012 *WHAT IS A PHOTOGRAPH*, NEW ORLEANS MUSEUM OF ART, NEW ORLEANS, LA.
2011 *THE 770 SHOW*, ADOBE BOOKS BACKROOM GALLERY, SAN FRANCISCO, CA
 OUR ORIGINS, MUSEUM OF CONTEMPORARY PHOTOGRAPHY, CHICAGO, IL.

2010	*Burning Desire*, Michael Mazzeo Gallery, New York, NY.
	Vertical Currency, Rochester Art Center, Rochester, MN.
2009	*Carroll/Nedrelow/Thompson*, Sellout Gallery, Minneapolis, MN.
	Arbor, Michael Mazzeo Gallery, New York, NY.
	First Impression, Camera Club of New York, New York, NY.
2008	*Pay Attention: GM08*, Soap Factory, Minneapolis, MN.
2007	*Ephemerality*, Ephemeral Space, Minneapolis, MN.
	Bamboo Festival, Anji, China
2006	*North American Graduate Art Survey*, Katherine Nash Gallery, Minneapolis, MN.
	Spark Festival of Electronic Music and Art, Minneapolis, MN.
	Above the 49th Parallel, Label Gallery, Winnipeg, Canada
2005	*Visible Fringe*, Minneapolis, MN.
	Rochester International Video Festival Rochester Art Center, Rochester, MN.
	Great Lakes Emerging Artists, SUNY, Fredonia, NY
2004	*City Scenes*, IDS Center, Minneapolis, MN.
	SPE Regional, University of Montana, Missoula, MT.

Awards/Honors/Publications

2012	*Baum Award for Emerging Photographers*
2011	*Artist in Residence*, Rayko Photo Center
2010	MacDowell Colony Fellowship, *Makeout Creek*, Issue #04
2009	*Art Review & Preview*, Issue #09
2008	*Lay Flat*, Issue #01, *I Have The Need To Destroy* - self published book and 7"
2007	*Fotohof commissioned mural*, Fhotohof, Salzburg, Austria.
2006	*Art City Professional Artist Residency*, Art City, Winnipeg, Manitoba.
	Blacklock Emerging Artist Fellowship, Blacklock Nature Sanctuary, MN.

CONTRIBUTORS

ALISON BRADLEY IS AN EDUCATOR, A CURATOR AND SPECIALIST IN PHOTOGRAPHY, WITH AN EMPHASIS ON 19TH CENTURY PHOTOGRAPHS OF THE MIDDLE EAST AND CONTEMPORARY PHOTOGRAPHY. SHE TEACHES AT THE INTERNATIONAL CENTER OF PHOTOGRAPHY (ICP) IN NEW YORK CITY. MOST RECENTLY, SHE CURATED A FEATURE ON THE PHOTOGRAPHS OF RUDY BURCKHARDT FOR *ACNE PAPER* ISSUE 14, WINTER 2012.

LYLE REXER IS THE AUTHOR OF MANY BOOKS ON ART AND PHOTOGRAPHY, INCLUDING *PHOTOGRAPHY'S ANTIQUARIAN AVANT-GARDE: THE NEW WAVE IN OLD PROCESSES*. HE TEACHES AT THE SCHOOL OF VISUAL ARTS IN NEW YORK CITY.

BOSI CONTEMPORARY WAS ESTABLISHED BY SANDRO BOSI, AN ART DEALER BASED IN ROME, LONDON AND NEW YORK. ACTIVE IN BOTH PRIMARY AND SECONDARY MARKERS, THE GALLERY OCCUPIES THE SPACE AT 48 ORCHARD STREET (BETWEEN GRAND AND HESTER) AND IT FOCUSES ITS ATTENTION ON CREATING A DYNAMIC SPACE FOR ARTISTS AND OTHER ART PRACTIONERS TO REALIZE THEIR VISION AND ESTABLISH A PLATFORM FOR DISCOURSE THAT WILL NURTURE A THOUGHTFUL AND CREATIVE COMMUNITY AS WELL AS ATTRACT NEW AUDIENCES.

INTERNATIONAL IN SCOPE, THE GALLERY EXHIBITS AND COMMUNICATES THE WORK OF BOTH EMERGING AND ESTABLISHED ARTISTS, SELECTED FOR THEIR UNIQUE AESTHETIC LANGUAGE AND FASCINATING VISION. IN ADDITION, BOSI CONTEMPORARY ANNUALLY ORGANIZES AN EXHIBITION DEDICATED TO AN ARTIST OF HISTORICAL IMPORTANCE.

Published by BOSI Contemporary, on the occasion of the exhibition Chuck Kelton & Eric William Carroll: *New Photogenic Drawings* on view from March 28 to April 21, 2013.

BOSI Contemporary
48 Orchard Street
New York, NY 10002
www.bosicontemporary.com

Copyright ©2013 BOSI Contemporary. All rights reserved.
Text copyright © 2012 the individual authors.

www.ingramcontent.com/pod-product-compliance
Lightning Source LLC
Chambersburg PA
CBHW051051180526
45172CB00002B/599